MW00628291

WERNER'S

NOMENCLATURE OF COLOURS.

WERNER'S
NOMENCLATURE OF COLOURS,

WITH ADDITIONS,

ARRANGED SO AS TO RENDER IT HIGHLY USEFUL

TO THE

ARTS AND SCIENCES,

PARTICULARLY

Zoology, Botany, Chemistry, Mineralogy, and Morbid Anatomy.

ANNEXED TO WHICH ARE

EXAMPLES SELECTED FROM WELL-KNOWN OBJECTS

IN THE

ANIMAL, VEGETABLE, AND MINERAL KINGDOMS.

BY

PATRICK SYME,

FLOWER-PAINTER, EDINBURGH;

PAINTER TO THE WERNERIAN AND HORTICULTURAL
SOCIETIES OF EDINBURGH.

EDINBURGH:

Printed by James Ballantyne and Co.

FOR WILLIAM BLACKWOOD, SOUTH-BRIDGE-STREET, EDINBURGH;
AND JOHN MURRAY, ALBEMARLE-STREET, AND ROBERT
BALDWIN, PATERNOSTER-ROW, LONDON.

1814.

WERNER'S

NOMENCLATURE OF COLOURS.

A NOMENCLATURE of colours, with pro-
per coloured examples of the different
tints, as a general standard to refer to in
the description of any object, has been
long wanted in arts and sciences. It is
singular, that a thing so obviously use-
ful, and in the description of objects of
natural history and the arts, where co-

A

lour is an object indispensably necessary, should have been so long overlooked. In describing an object, to specify its colours is always useful; but where colour forms a character, it becomes absolutely necessary. How defective, therefore, must description be when the terms used are ambiguous; and where there is no regular standard to refer to. Description without figure is generally difficult to be comprehended; description and figure are in many instances still defective; but description, figure, and colour combined form the most perfect representation, and are next to seeing the object itself. An object may be

described of such a colour by one person, and perhaps mistaken by another for quite a different tint : as we know the names of colours are frequently misapplied; and often one name indiscriminately given to many colours. To remove the present confusion in the names of colours, and establish a standard that may be useful in general science, particularly those branches, viz. Zoology, Botany, Mineralogy, Chemistry, and Morbid Anatomy, is the object of the present attempt.

The author, from his experience and long practice in painting objects which

required the most accurate eye to distin-
guish colours, hopes that he will not be
thought altogether unqualified for such
an undertaking. He does not pretend
indeed that it is his own idea; for, so far
as he knows, Werner is entitled to the
honour of having suggested it. This
great mineralogist, aware of the import-
ance of colours, found it necessary to
establish a Nomenclature of his own in
his description of minerals, and it is as-
tonishing how correct his eye has been;
for the author of the present undertaking
went over Werner's suites of colours, be-
ing assisted by Professor Jamieson, who
was so good as arrange on a table, spe-

cimens of the suites of minerals mention-
ed by Werner, as examples of his No-
menclature of Colours. He copied the
colours of these minerals, and found the
component parts of each tint, as men-
tioned by Werner, uncommonly correct.
Werner's suites of colours extend to se-
venty-nine tints. Though these may an-
swer for the description of most minerals,
they would be found defective when ap-
plied to general science : the number
therefore is extended to one hundred and
eight, comprehending the most·common
colours or tints that appear in nature.
These may be called standard colours ;
and if the terms pale, deep, dark, bright,

and dull be applied to any of the standard colours, suppose crimson, or the same colour tinged lightly with other colours, suppose grey, or black, or brown, and applied in this manner :

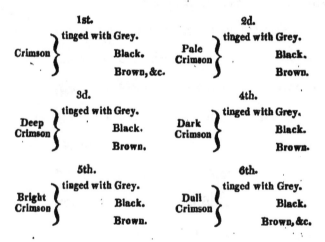

1st.

Crimson { tinged with Grey. Black. Brown, &c.

2d.

Pale Crimson { tinged with Grey. Black. Brown.

3d.

Deep Crimson { tinged with Grey. Black. Brown.

4th.

Dark Crimson { tinged with Grey. Black. Brown.

5th.

Bright Crimson { tinged with Grey. Black. Brown.

6th.

Dull Crimson { tinged with Grey. Black. Brown, &c.

If all the standard colours are applied in this manner, or reversed, as grey tinged

with crimson, &c. the tints may be mul-
tiplied to upwards of thirty thousand,
and yet vary very little from the stand-
ard colours with which they are com-
bined. The suites of colours are accom-
panied with examples in, or references
to, the Animal, Vegetable, and Mineral
Kingdoms, as far as the author has been
able to fill them up, annexed to each
tint, so as to render the whole as com-
plete as possible. Werner, in his suites of
colours, has left out the terms Purple
and Orange, and given them under those
of Blue and Yellow; but, with deference
to Werner's opinion, they certainly are
as much entitled to the name of colours

as green, grey, brown, or any other composition colour whatever, and in this work are therefore arranged in distinct places. To accomplish which, it was necessary to change the places of two or three of Werner's colours, and alter the names of a few more; but, to avoid any mistake, the letter W. is placed opposite to all Werner's colours. Those colours in Werner's suites, whose places or names are changed, are also explained, by placing Werner's term opposite to the name given, which was found more appropriate to the component parts of the changed colours. Those who have paid any attention to colours, must be aware that it

is very difficult to give colours for every object that appears in nature; the tints are so various, and the shades so gradual, they would extend to many thousands: it would be impossible to give such a number, in any work on colours, without great expence; but those who study the colours given, will, by following Werner's plan, improve their general knowledge of colours; and the eye, by practice, will become so correct, that by examining the component parts of the colour of any object, though differing in shade from any of the colours given in this series, they will see that it partakes of, or passes into, some one of them. It

is of great importance to be able to judge
of the intermediate shades or tints be-
tween colours, and find out their com-
ponent parts, as it enables us correctly
to describe the colour of any object
whatever.

Werner's plan for describing the tints,
or shades between colours, is as follows :
" When one colour approaches slightly to
another, it is said to incline towards it;
when it stands in the middle between two
colours, it is said to be intermediate; when,
on the contrary, it evidently approaches
very near to one of the colours, it is said
to fall, or pass, into it." In this work the

metallic colours are left out, because, were they given, they would soon tarnish; and they are in some measure unnecessary, as every person is well acquainted with the colour of gold, silver, brass, copper, &c. Also the play of colour is left out, as it is impossible to represent it; but it is well known to be a combination of colours, varying as the object is changed in position, as in the pigeon's neck, peacock's tail, opal, pearl, and objects of a similar appearance. To gain a thorough knowledge of colours, it is of the utmost consequence to be able to distinguish their component parts. Werner has described the combinations

in his suites of colours, which are very
correct; these are given, and the same
plan followed in describing those colours
which are added in this series. The me-
thod of distinguishing colours, their
shades, or varieties, is thus described by
Werner: " Suppose we have a variety of
colour, which we wish to refer to its cha-
racteristic colour, and also to the variety
under which it should be arranged, we
first compare it with the principal co-
lours, to discover to which of them it
belongs, which, in this instance, we find
to be green. The next step is to discover
to which of the varieties of green in the
system it can be referred. If, on compa-

ring it with emerald green, it appears to
the eye to be mixed with another colour,
we must, on comparison, endeavour to
discover what this colour is: if it prove
to be greyish white, we immediately re-
fer it to apple green; if, in place of
greyish white, it is intermixed with le-
mon yellow, we must consider it grass
green; but if it contains neither greyish
white nor lemon yellow, but a consider-
able portion of black, it forms blackish
green. Thus, by mere ocular inspec-
tion, any person accustomed to discrimi-
nate colours correctly, can ascertain and
analyse the different varieties that occur
in the Animal, Vegetable, and Mineral

Kingdoms." In an undertaking of this
kind, the greatest accuracy being abso-
lutely necessary, neither time nor pains
has been spared to render it as perfect
as possible; and it being also of the first
importance, that the colours should nei-
ther change nor fade, from long practice
and many experiments, the author has
ascertained that his method of mixing
and laying on colours will ensure their
remaining constant, unless they are long
exposed to the sun, which affects, in some
degree, all material colours; he has there-
fore arranged Werner's suites of colours,
with his own additions, into a book, and
in that form presents it to men of science,

trusting, that by removing the present ambiguity in the names of colours, this Nomenclature will be found a most useful acquisition to the arts and sciences.

COMPONENT PARTS

THE COLOURS

GIVEN IN

THIS SERIES.

———

WHITES.

No. 1. Snow White, is the characteristic colour of the whites; it is the purest white colour; being free of all intermixture, it resembles new-fallen snow. W.

2. Reddish White, is composed of snow white with a very minute portion of crimson red and ash grey. W.

3. Purplish White, is snow white with the slightest tinge of crimson red and Berlin blue, and a very minute portion of ash grey.

B

No. 4. Yellowish White, is composed of snow white, with a very little lemon yellow and ash grey. W.

5. Orange-coloured White, is snow white with a very small portion of tile red and king's yellow, and a minute portion of ash grey.

6. Greenish White, is snow white mixed with a very little emerald green and ash grey. W.

7. Skimmed-milk White, is snow white mixed with a little Berlin blue and ash grey. W.

8. Greyish White, is snow white mixed with a little ash grey. W.

GREYS.

No. 9. Ash Grey, is the characteristic colour
of Werner's greys; he gives no de-
scription of its component parts; it is
composed of snow white, with por-
tions of smoke and French grey, and
a very little yellowish grey and car-
mine red. **W.**

10. Smoke Grey, is ash grey mixed with a
little brown. **W.**

11. French Grey, nearly the steel grey of
Werner, without the lustre, is greyish
white, with a slight tinge of black and
carmine red.

12. Pearl Grey, is ash grey mixed with a
little crimson red and blue, or bluish
grey with a little red. **W.**

No. 13. Yellowish Grey, is ash grey mixed with
lemon yellow and a minute portion of
brown. W.

14. Bluish Grey, is ash grey mixed with a
little blue. W.

15. Greenish Grey, is ash grey mixed with
a little emerald green, a small por-
tion of black, and a little lemon yel-
low. W.

16. Blackish Grey, blackish lead grey of
Werner without the lustre, is ash
grey, with a little blue and a portion
of black.

BLACKS.

No. 17. Greyish Black, is composed of velvet black, with a portion of ash grey. W.

18. Bluish Black, is velvet black mixed with a little blue and blackish grey. W.

19. Greenish Black, is velvet black mixed with a little brown, yellow, and green. W.

20. Pitch, or Brownish Black, is velvet black mixed with a little brown and yellow. W.

21. Reddish Black, is velvet black mixed with a very little carmine red and a small portion of chesnut brown.

22. Raven Black, is velvet black with a little indigo blue in it.

23. Velvet Black, is the characteristic co-
lour of the blacks; it is the colour of
black velvet. W.

BLUES.

No. 24. Indigo Blue, is Berlin blue mixed with a considerable portion of velvet black, a very little grey, and a slight tinge of carmine red. W.

25. Prussian Blue, is Berlin blue with a considerable portion of velvet black, and a small quantity of indigo blue.

26. China Blue, is azure blue with a little Prussian blue in it.

27. Azure Blue, is Berlin blue mixed with a little carmine red: it is a burning colour. W.

28. Ultramarine Blue, is a mixture of equal parts of Berlin and azure blue.

No. 29. Flax-Flower Blue, is Berlin blue with a slight tinge of ultramarine blue.

30. Berlin Blue, is the pure, or characteristic colour of Werner. W.

31. Verditter Blue, is Berlin blue with a small portion of verdigris green.

32. Greenish Blue, the sky blue of Werner, is composed of Berlin blue, white, and a little emerald green. W.

33. Greyish Blue, the smalt blue of Werner, is composed of Berlin blue, with white, a small quantity of grey, and a hardly perceptible portion of red. W.

PURPLES.

No. 34. Bluish Lilac Purple, is bluish purple and white.

35. Bluish Purple, is composed of about equal parts of Berlin blue and carmine red.

36. Violet Purple, violet blue of Werner, is Berlin blue mixed with red, and a little brown. W.

37. Pansy Purple, is indigo blue with carmine red, and a slight tinge of raven black.

38. Campanula Purple, is ultramarine blue and carmine red, about equal parts of each: it is the characteristic colour.

No. 39. Imperial Purple, is azure and indigo blue with carmine red, about equal parts of each.

40. Auricula Purple, is plum purple with indigo blue and much carmine red.

41. Plum Purple, the plum blue of Werner, is composed of Berlin blue with much carmine red, a very little brown, and an almost imperceptible portion of black. W.

42. Red Lilac Purple, is campanula purple with a considerable portion of snow white, and a very little carmine red.

43. Lavender Purple, the lavender blue of Werner, is composed of blue, red, and a little brown and grey. W.

No. 44. Pale Bluish Purple, is lavender purple mixed with a little red and black.

GREENS.

No. 45. Celindine Green, is composed of verdigris green and ash grey. **W.**

46. Mountain Green, is composed of emerald green, with much blue and a little yellowish grey. **W.**

47. Leek Green, is composed of emerald green, with a little brown and bluish grey. **W.**

48. Blackish Green, is grass green mixed with a considerable portion of black. **W.**

49. Verdigris Green, is composed of emerald green, much Berlin blue, and a little white. **W.**

No. 50. Bluish Green, is composed of Berlin blue and a little lemon yellow and greyish white.

51. Apple Green, is emerald green mixed with a little greyish white. W.

52. Emerald Green, is the characteristic colour of Werner; he gives no description of the component parts of any of the characteristic colours; it is composed of about equal parts of Berlin blue and gamboge yellow.

53. Grass Green, is emerald green mixed with a little lemon yellow. W.

54. Duck Green, W. a new colour of Werner's, added since the publication of his nomenclature; it is composed of

emerald green with a little indigo
blue, much gamboge yellow, and a
very little carmine red.

No. 55. Sap Green, is emerald green with much
saffron yellow and a little chesnut
brown.

56. Pistachio Green, is emerald green mix-
ed with a little lemon yellow and a
small quantity of brown. W.

57. Asparagus Green, is pistachio green,
mixed with much greyish white. W.

58. Olive Green, is grass green mixed with
much brown. W.

59. Oil Green, is emerald green mixed with
lemon yellow, chesnut brown, and
yellowish grey. W.

No. 60. Siskin Green, is emerald green mixed
with much lemon yellow and a little
yellowish white. W.

YELLOWS.

No. 61. Sulphur Yellow, is lemon yellow, mixed
with emerald green and white. **W.**

62. Primrose Yellow, is gamboge yellow
mixed with a little sulphur yellow
and much snow white.

63. Wax Yellow, is composed of lemon
yellow, reddish brown, and a little
ash grey. **W.**

64. Lemon Yellow, the characteristic co-
lour of the yellow series of Werner,
the colour of ripe lemons; W. it is
found to be a mixture of gamboge
yellow and a little ash grey: being a
mixed colour, it cannot be adopted
as the characteristic colour; the cha-
racteristic colours of the blues, reds,

10

and yellows ought to be pure and
free from all intermixture with any
other colour ; gamboge, as the purest
yellow colour, is adopted instead of
lemon yellow, as the characteristic
colour of the yellows.

No. 65. Gamboge Yellow, is the characteristic
colour.

66. King's Yellow, is gamboge yellow with
a small portion of saffron yellow.

67. Saffron Yellow, is gamboge yellow with
gallstone yellow, about equal parts of
each.

68. Gallstone Yellow, is gamboge yellow
with a small quantity of Dutch orange,

c

and a minute proportion of honey
yellow.

No. 69. Honey Yellow, is sulphur yellow mixed
with chesnut brown. W.

70. Straw Yellow, is sulphur yellow mixed
with much greyish white and a little
ochre yellow. W.

71. Wine Yellow, is sulphur yellow mixed
with reddish brown and grey, with
much snow white. W.

72. Sienna Yellow, is primrose yellow with
a little ochre yellow.

73. Ochre Yellow, is sienna yellow with a
little light chesnut brown. W.

74. Cream Yellow, is ochre yellow mixed with a little white, and a very small quantity of Dutch orange. W.

ORANGE.

No. 75. Dutch Orange, the orange yellow of
Werner, is gamboge yellow with car-
mine red. W.

76. Buff Orange, is sienna yellow with a
little Dutch orange.

77. Orpiment Orange, the characteristic
colour, is about equal parts of gam-
boge yellow and arterial blood red.

78. Brownish Orange, is orpiment orange,
with a little hyacinth red and a small
quantity of light chesnut brown.

79. Reddish Orange, is buff orange mixed
with a considerable portion of tile
red.

No. 80. Deep Reddish Orange, is Dutch orange
mixed with much scarlet red.

REDS.

No. 81. Tile Red, is hyacinth red mixed with much greyish white, and a small portion of scarlet red. W.

82. Hyacinth Red, is scarlet red with lemon yellow and a minute proportion of brown. W.

83. Scarlet Red, is arterial blood red with a little gamboge yellow.

84. Vermilion Red, is scarlet red with a minute portion of brownish red.

85. Aurora Red, is tile red with a little arterial blood red, and a slight tinge of carmine red. W.

86. Arterial Blood Red, is the characteristic colour of the red series.

No. 87. Flesh Red, is rose red mixed with tile red and a little white. W.

88. Rose Red, is carmine red with a great quantity of snow white, and a very small portion of cochineal red. W.

89. Peach Blossom Red, is lake red mixed with much white. W.

90. Carmine Red, the characteristic colour of Werner, is lake red with a little arterial blood red. W.

91. Lake Red, the crimson red of Werner, is arterial blood red, with a portion of Berlin blue. W.

92. Crimson Red, the columbine red of Werner, is carmine red with a little

Berlin blue, and a small portion of indigo blue. W.

No. 93. Cochineal Red, is lake red mixed with bluish grey. W.

94. Veinous Blood Red, is carmine red mixed with brownish black. W.

95. Brownish Purple Red, the cherry red of Werner, is lake red mixed with brownish black, and a small portion of grey. W.

96. Chocolate Red, is veinous blood red mixed with a little brownish red.

97. Brownish Red, is chocolate red mixed with hyacinth red, and a little chesnut brown. W.

BROWNS.

No. 98. Deep Orange-coloured Brown, is chesnut brown with a little reddish brown, and a small quantity of orange brown.

99. Deep Reddish Brown, is chesnut brown with a little chocolate red.

100. Umber Brown, is chesnut brown with a little blackish brown.

101. Chesnut Brown, the characteristic colour of the browns of Werner's series, W. is deep reddish brown and yellowish brown.

102. Yellowish Brown, is chesnut brown mixed with a considerable portion of lemon yellow. W.

D

No. 103. Wood Brown, is yellowish brown mixed with ash grey.

104. Liver Brown, is chesnut brown mixed with a little black and olive green.

105. Hair Brown, is clove brown mixed with ash grey. W.

106. Broccoli Brown, is clove brown mixed with ash grey, and a small tinge of red. W.

107. Olive Brown, is ash grey mixed with a little blue, red, and chesnut brown. W.

108. Blackish Brown, is composed of chesnut brown and black. W.

LIST OF COLOURS

CHANGED FROM WERNER'S ARRANGEMENT.

=====

Werner's Names	*Changed to*
Milk White.	Skimmed Milk White.
Blackish Lead Grey, but without lustre.	Blackish Grey.
Steel Grey, but without lustre.	French Grey.
Smalt Blue.	Greyish Blue.
Sky Blue.	Greenish Blue.
Violet Blue.	Violet Purple.
Plum Blue.	Plum Purple.
Lavender Blue.	Lavender Purple.
Orange Yellow.	Dutch Orange.
Crimson Red.	Lake Red.
Columbine Red.	Crimson Red.
Cherry Red.	Brownish Purple Red.

Printed in the USA
CPSIA information can be obtained
at www.ICGtesting.com
LVHW021411311023
762448LV00005B/321

9 781015 409071